THE OFFICIAL MINECRAFT COLORING BOOK

VOLUME 2

INSIGHT
EDITIONS

SAN RAFAEL · LOS ANGELES · LONDON

Hello Friend!

In this amazing coloring book, you can show off your awesome creativity while mining, building, and exploring Minecraft's expansive world! Within these pages, your sense of adventure will be put to the test as you color iconic biomes, mobs, and items and embark on a colorful, artful journey. Facing hordes of creepers, spiders, and zombies, you'll need your colored pencils, crayons, or markers—and your imagination—to create something incredible! Now, get ready to color, adventure, and explore!

Have Fun!

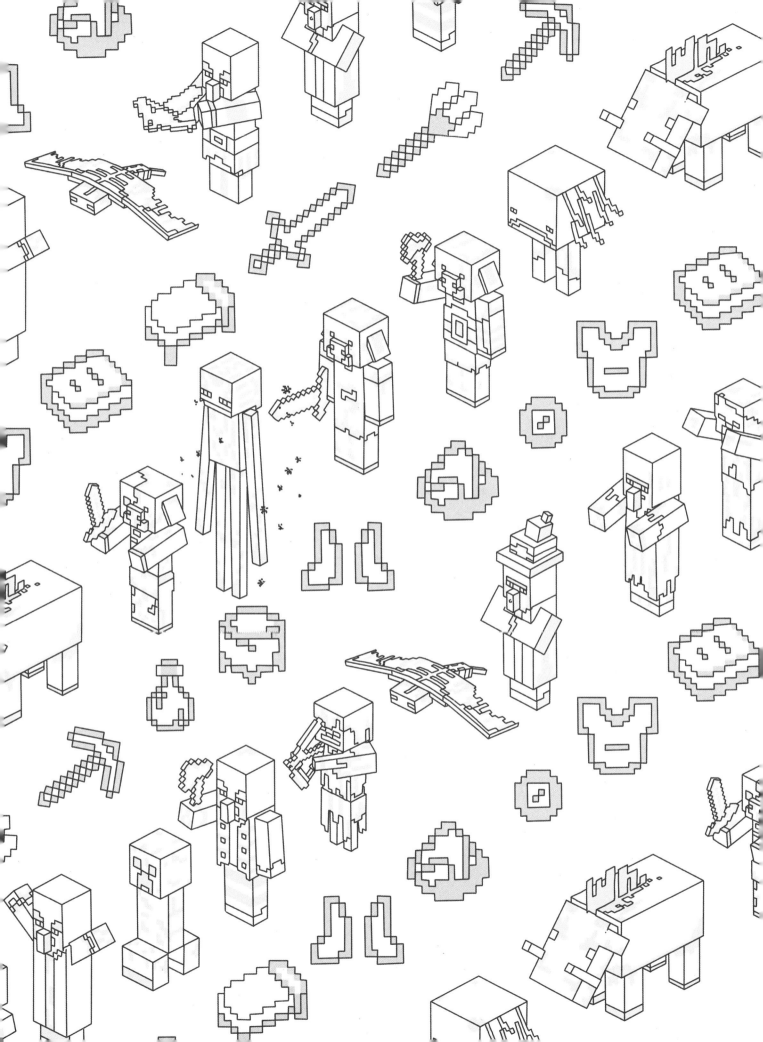

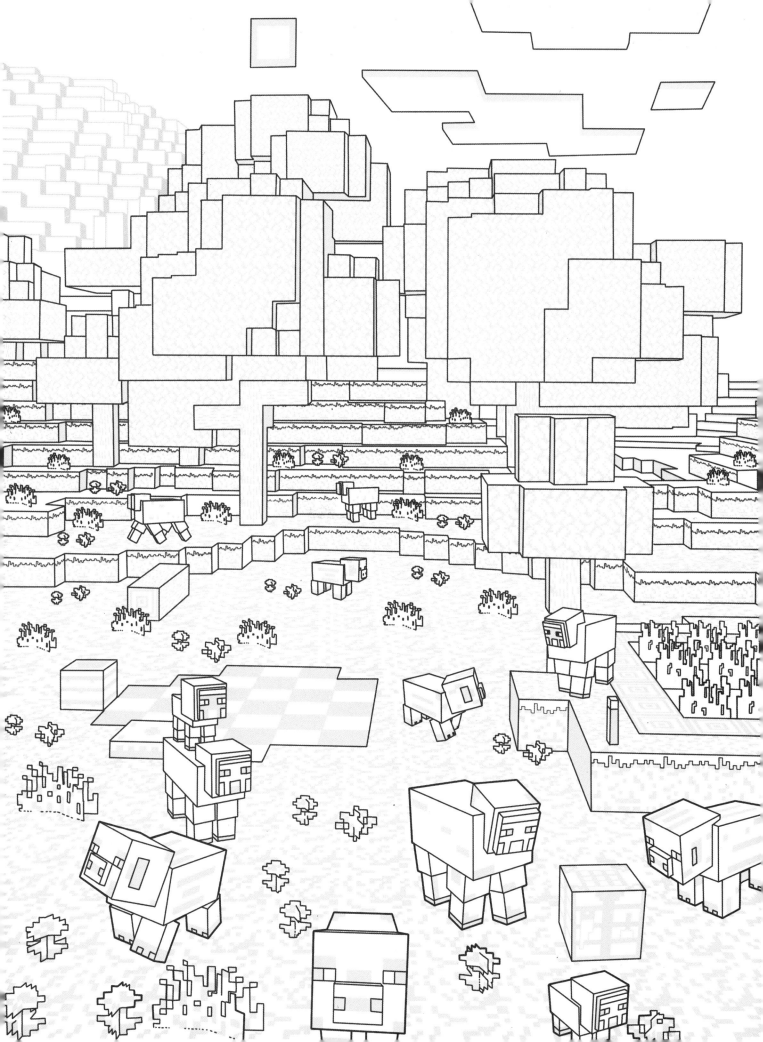

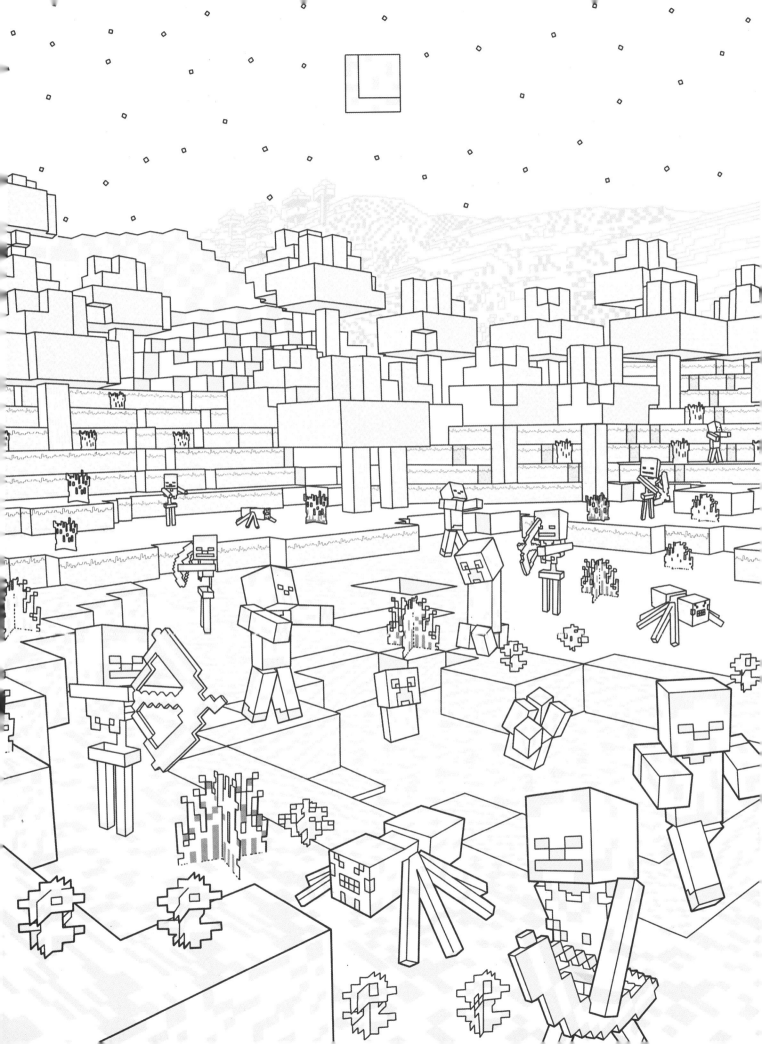

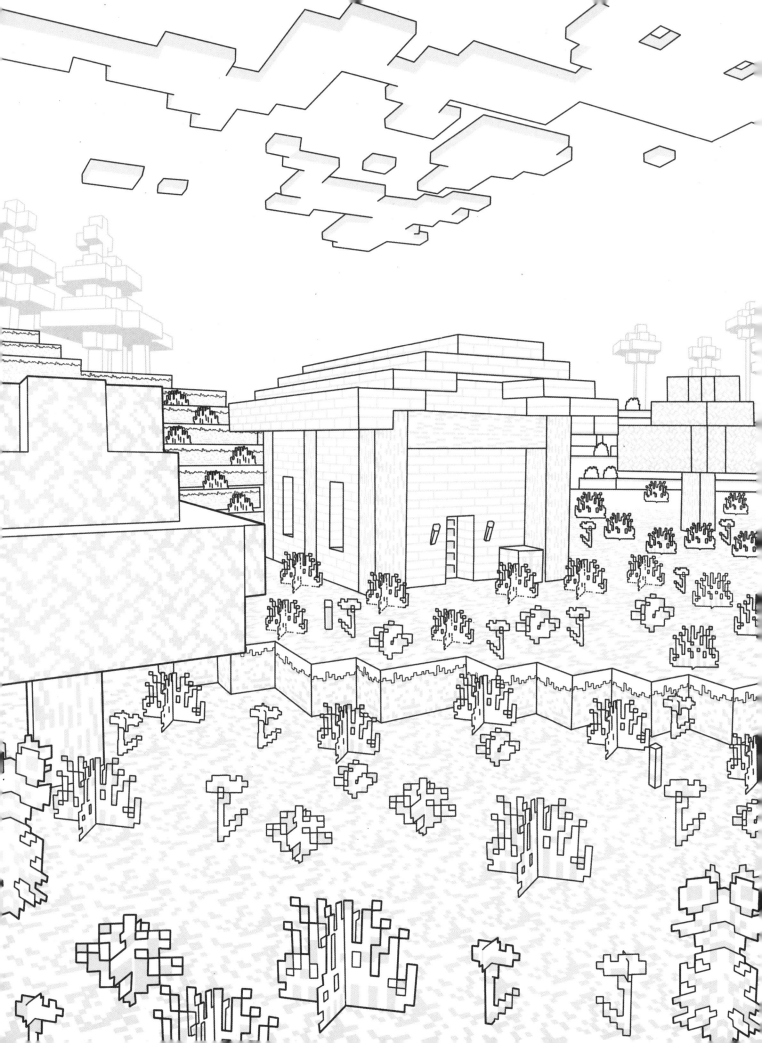

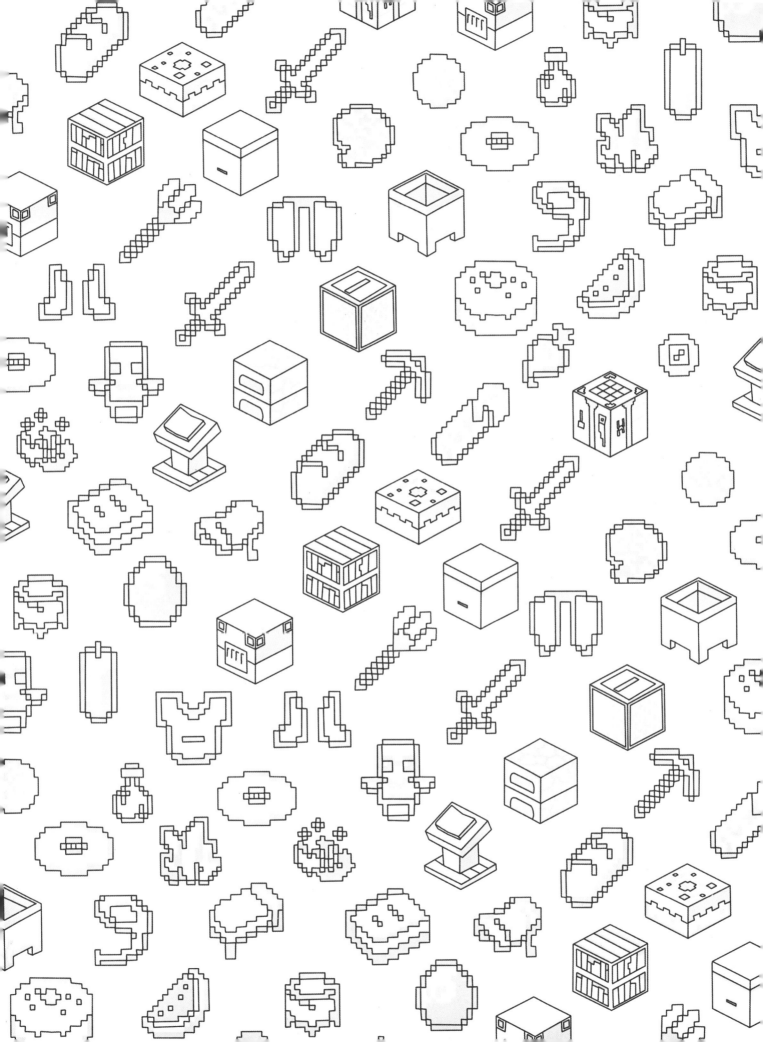

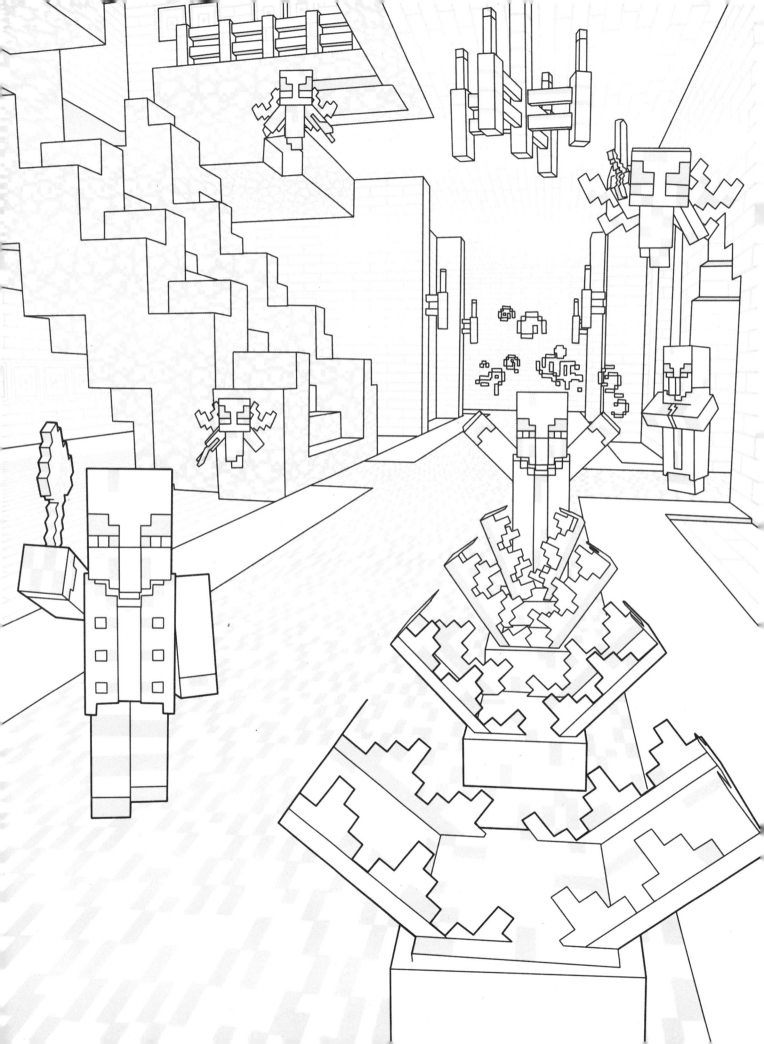

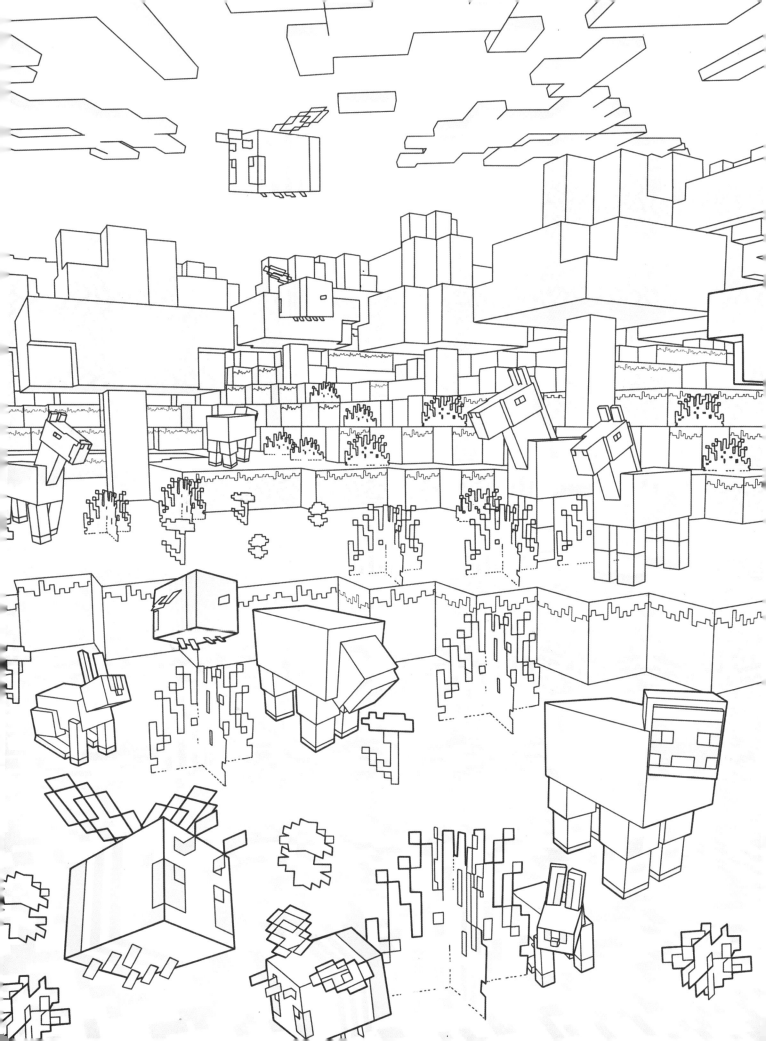

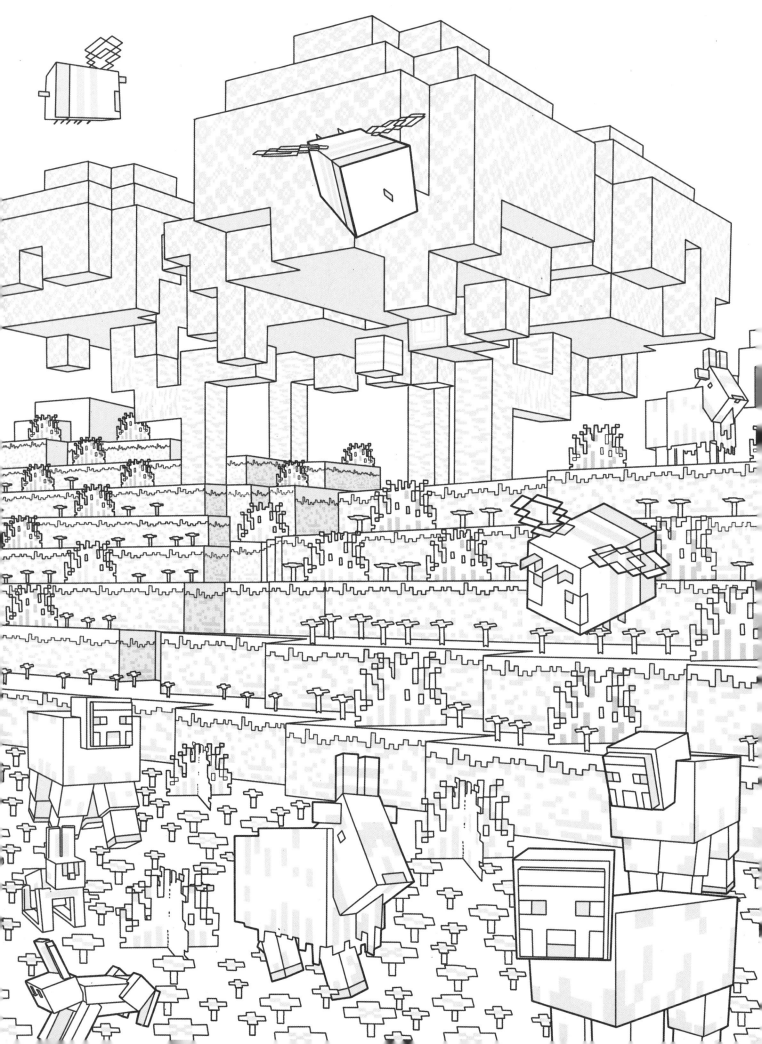

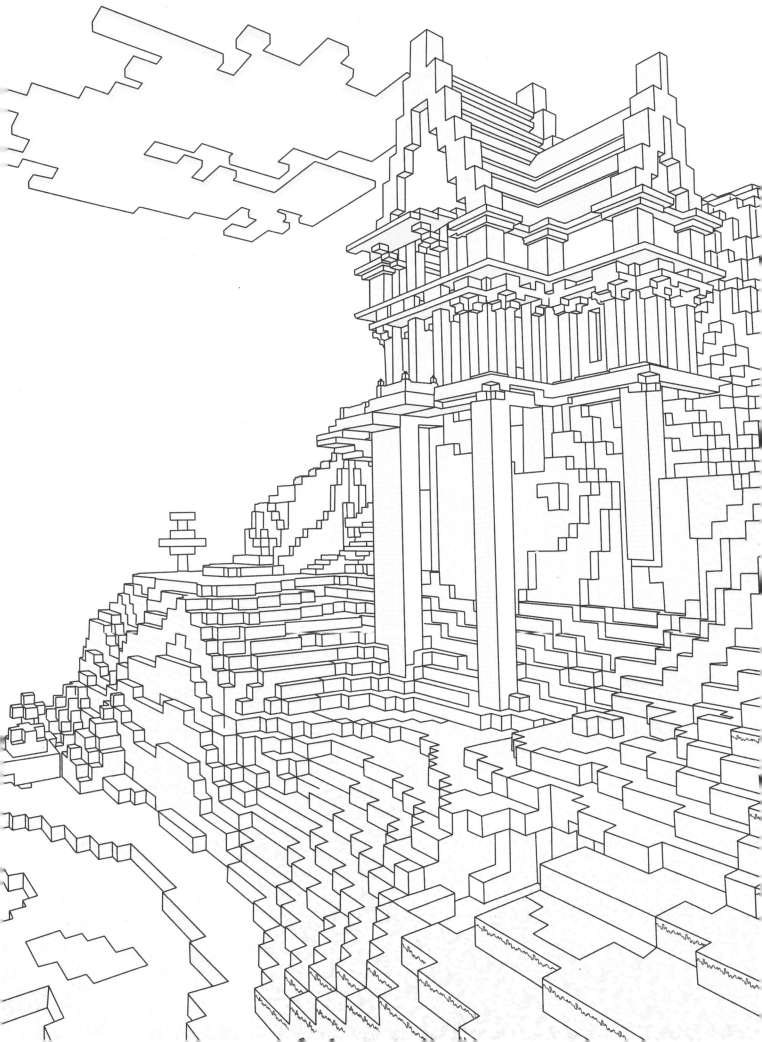

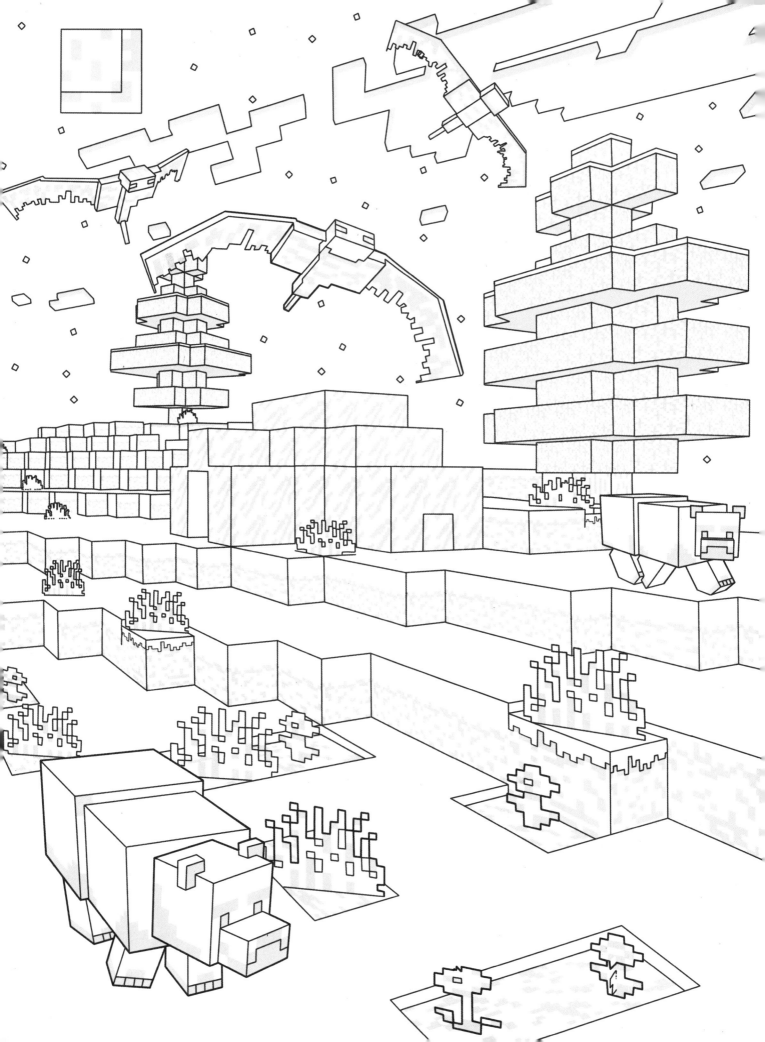

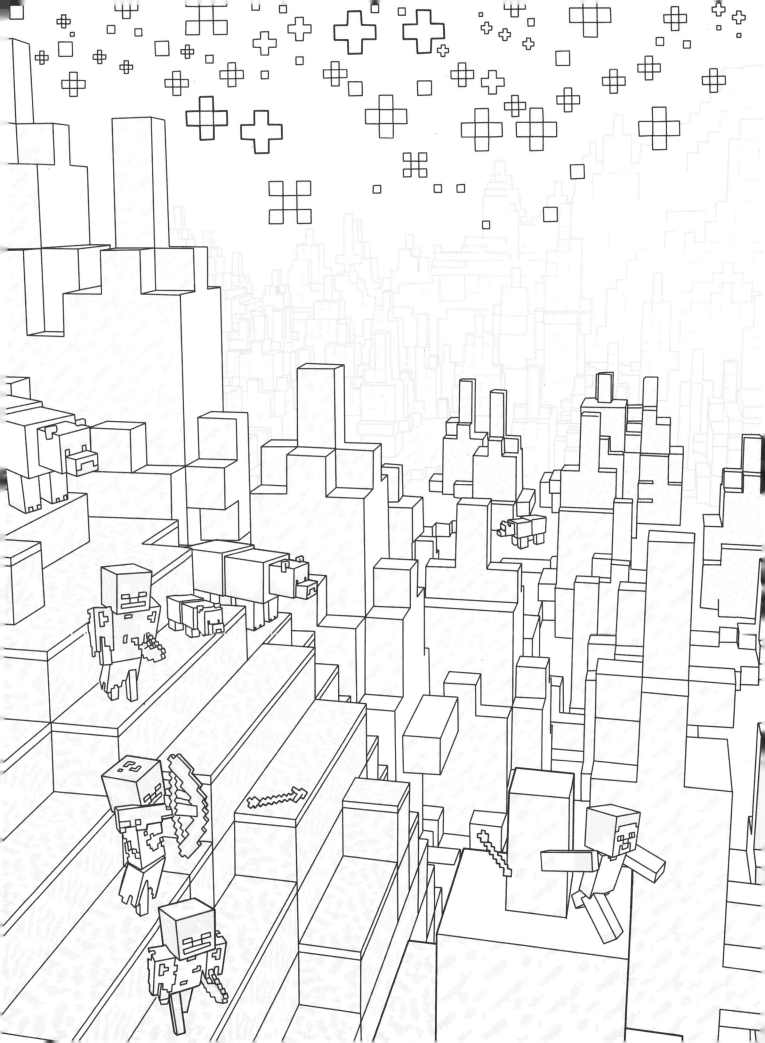

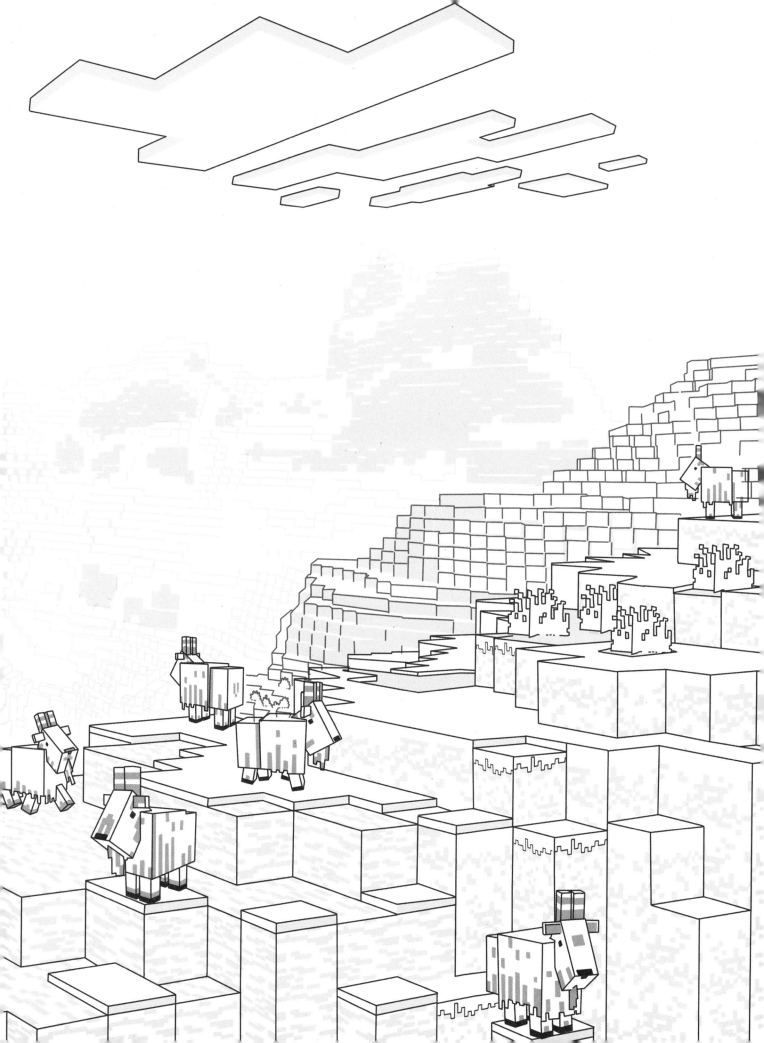

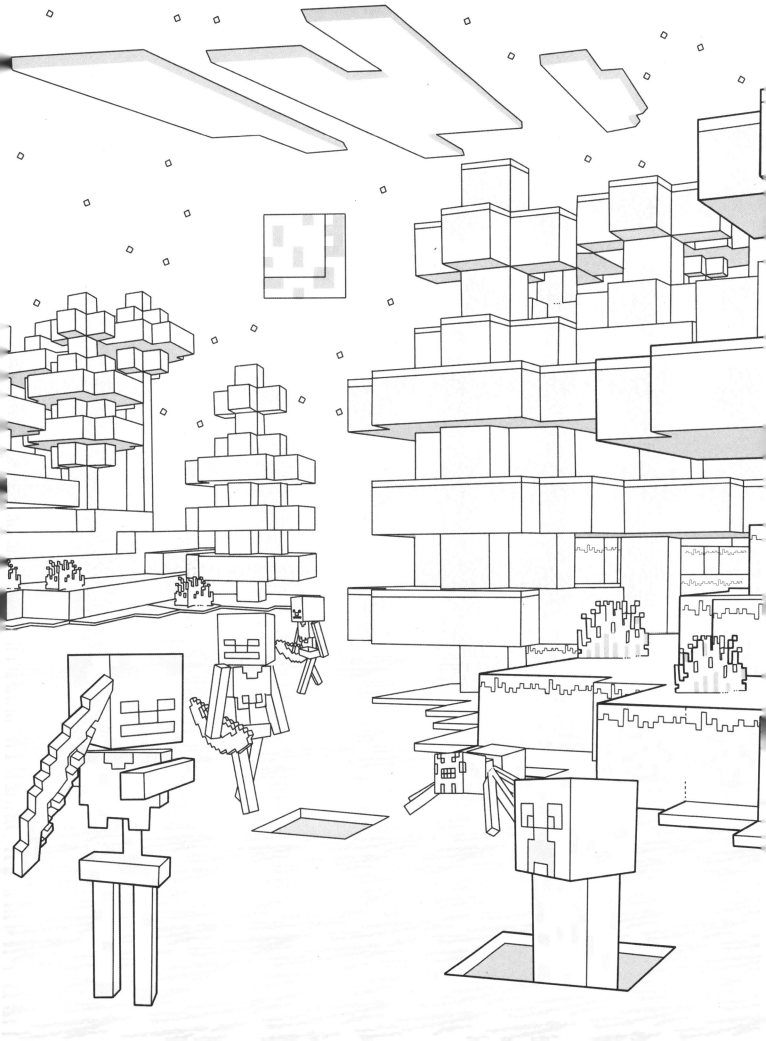

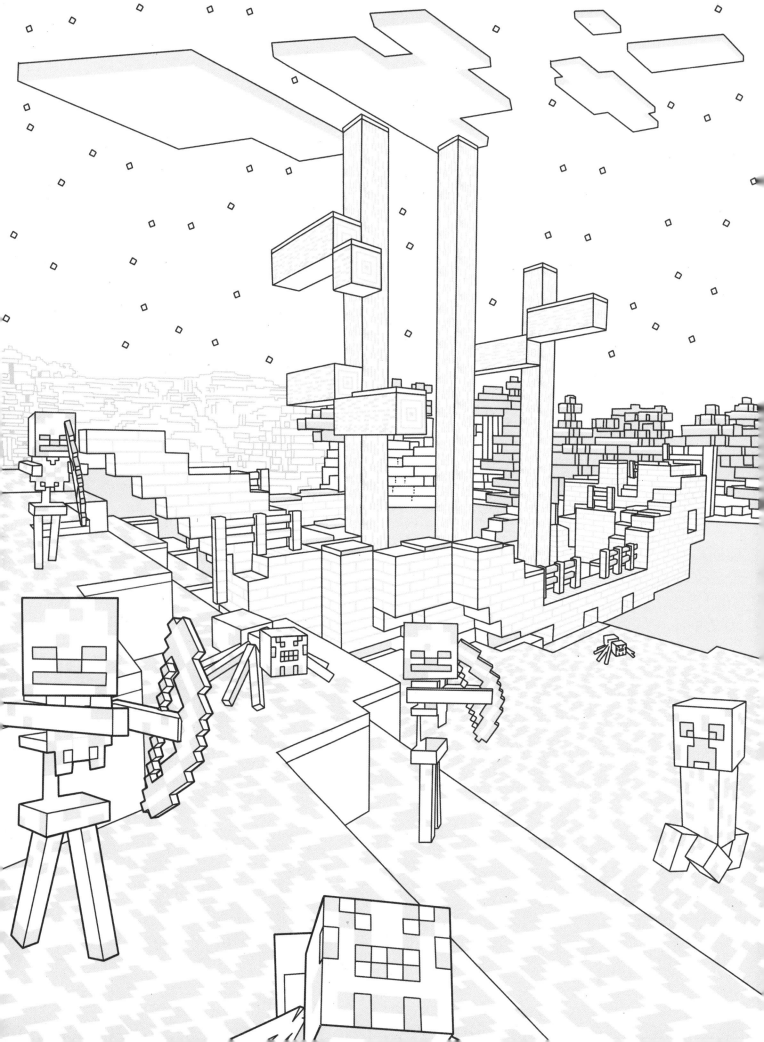

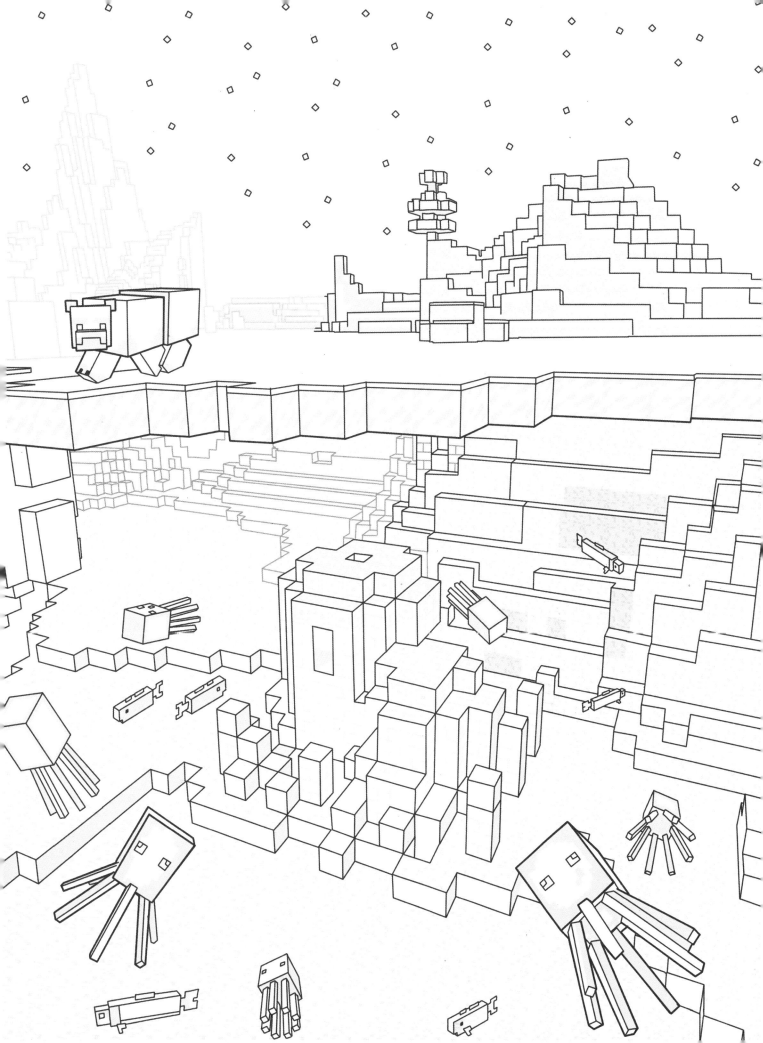

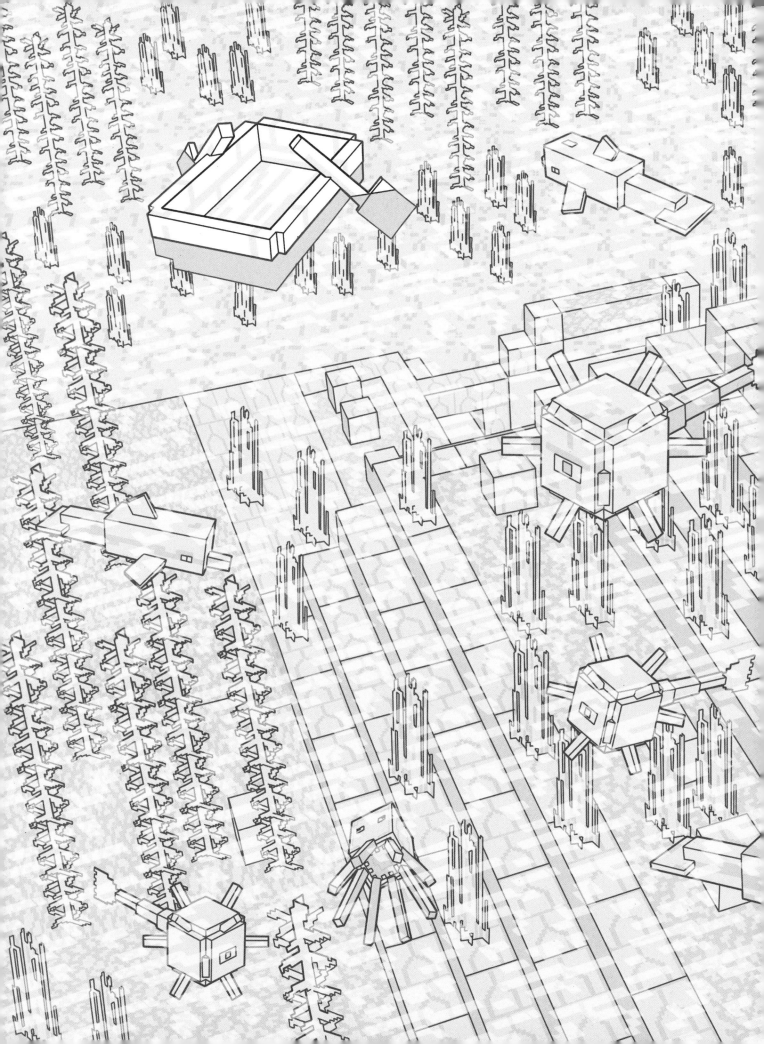

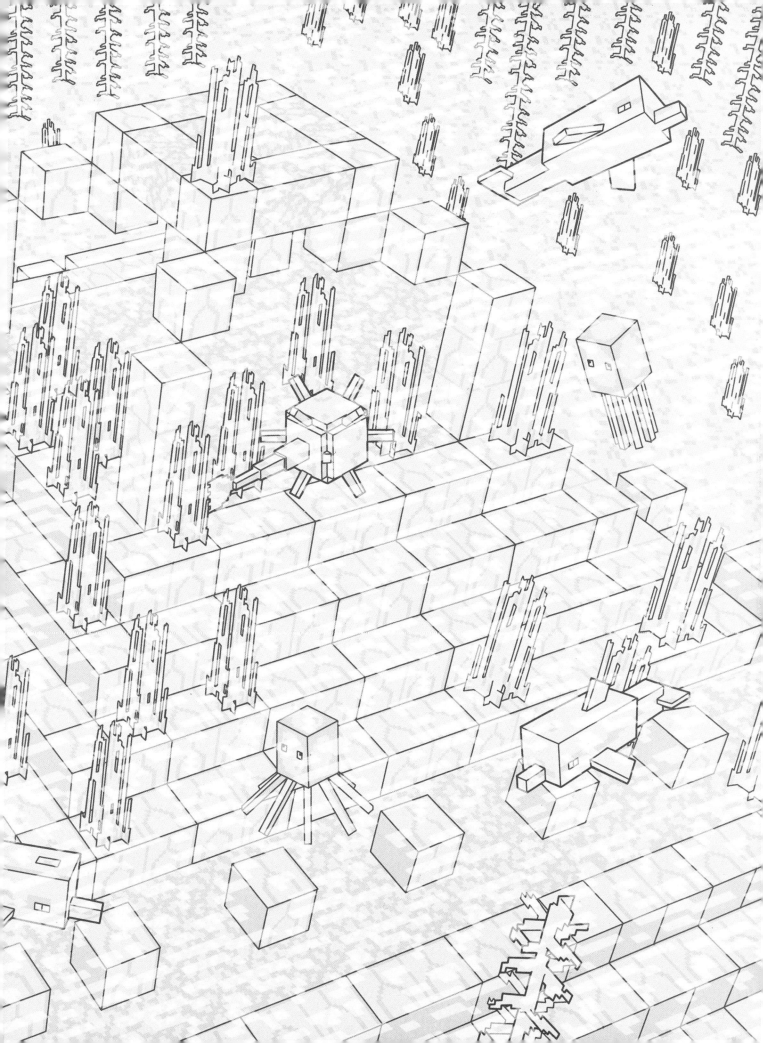

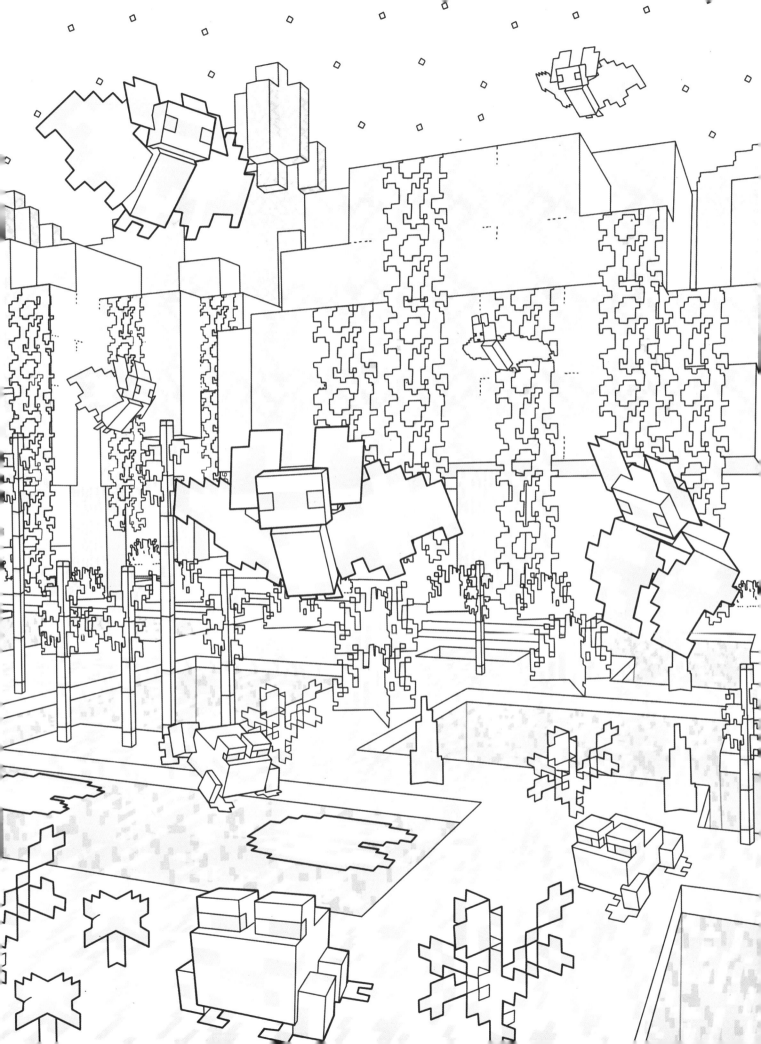

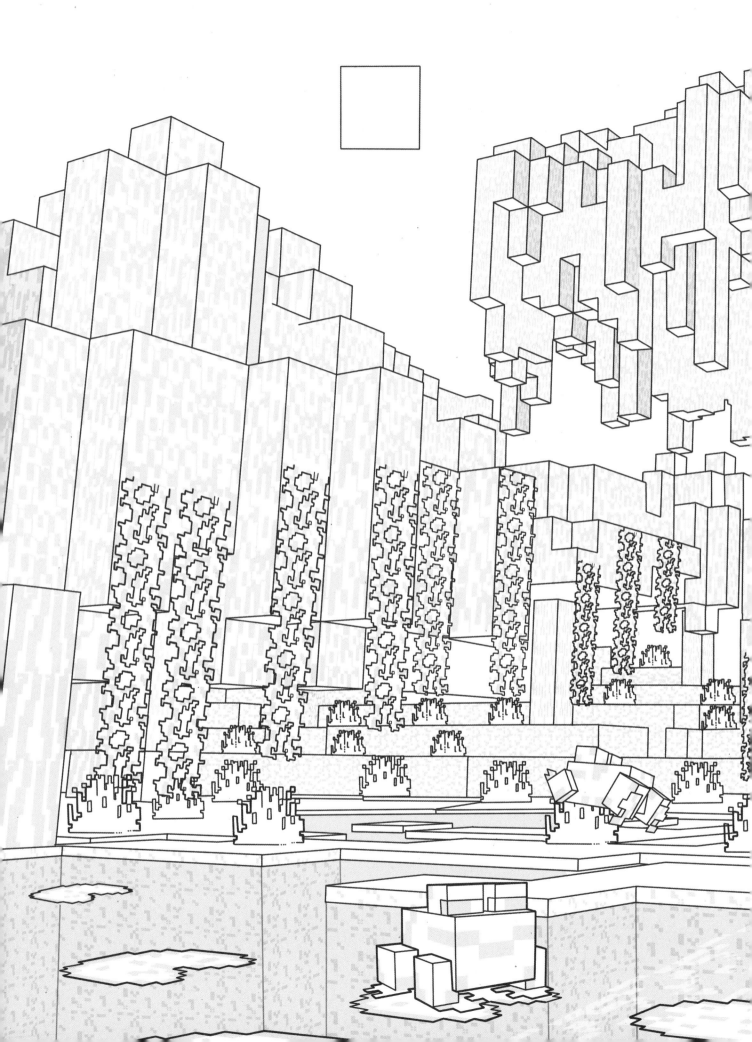

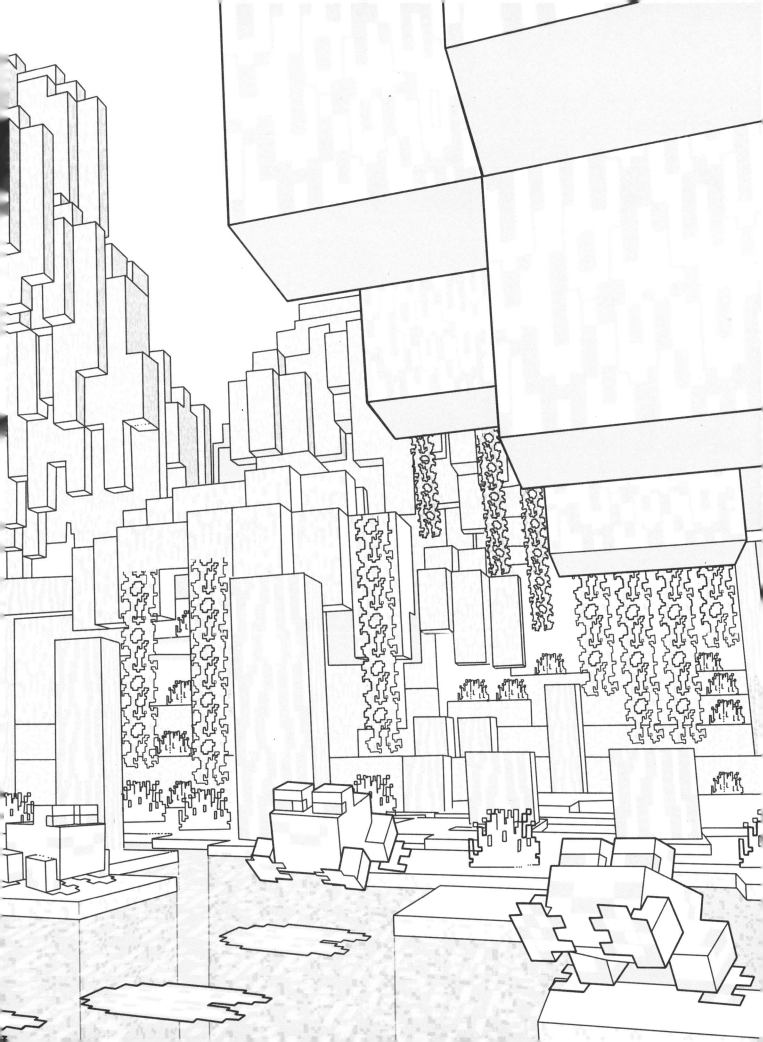

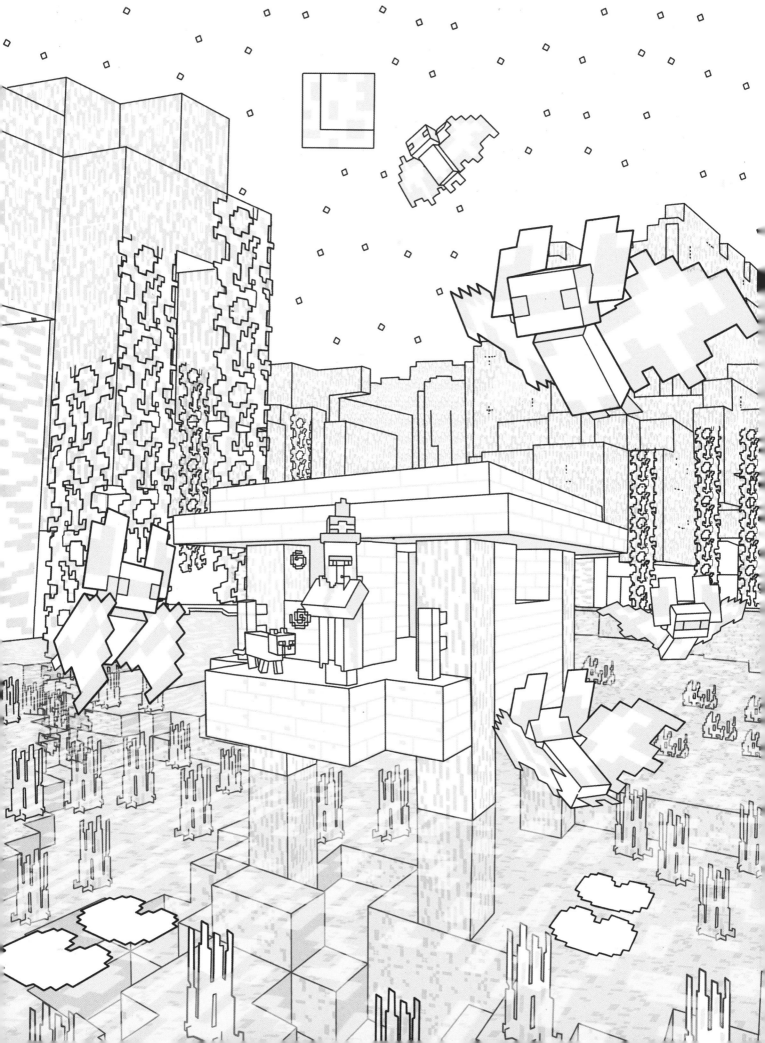

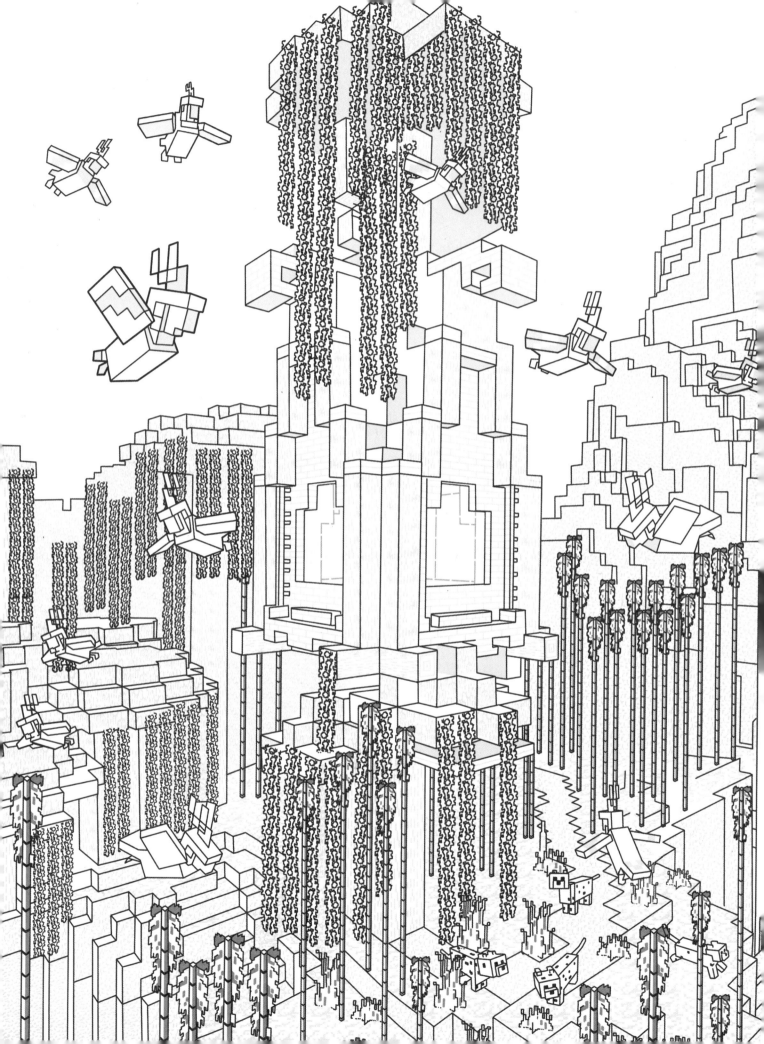

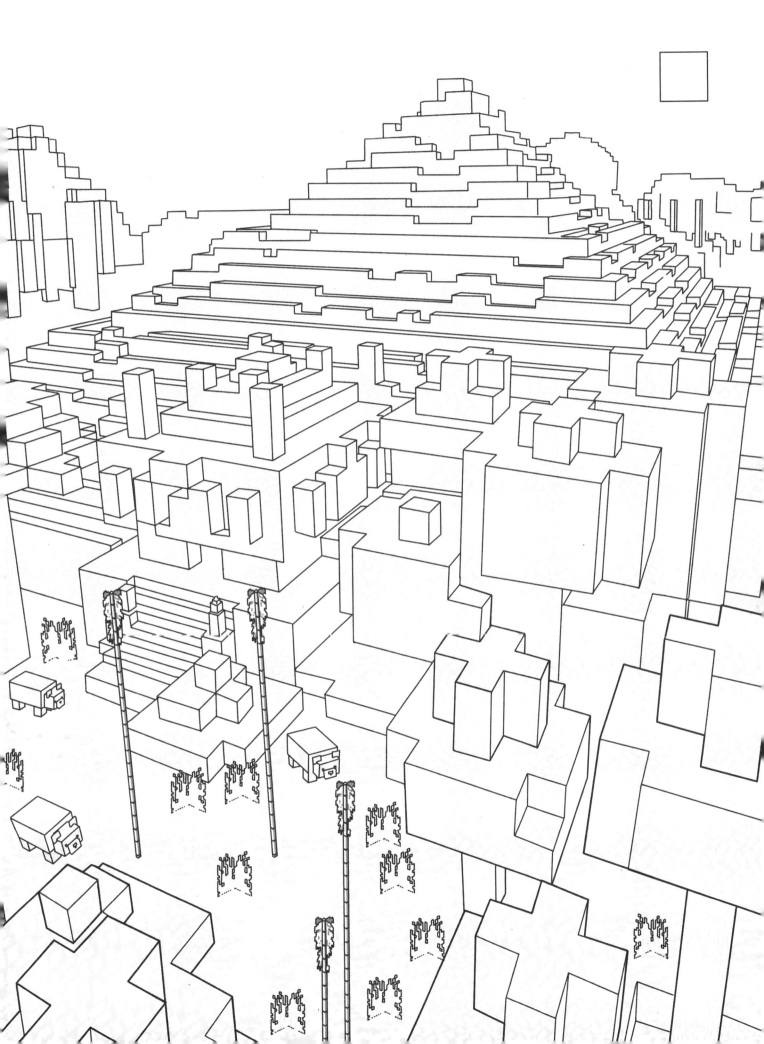

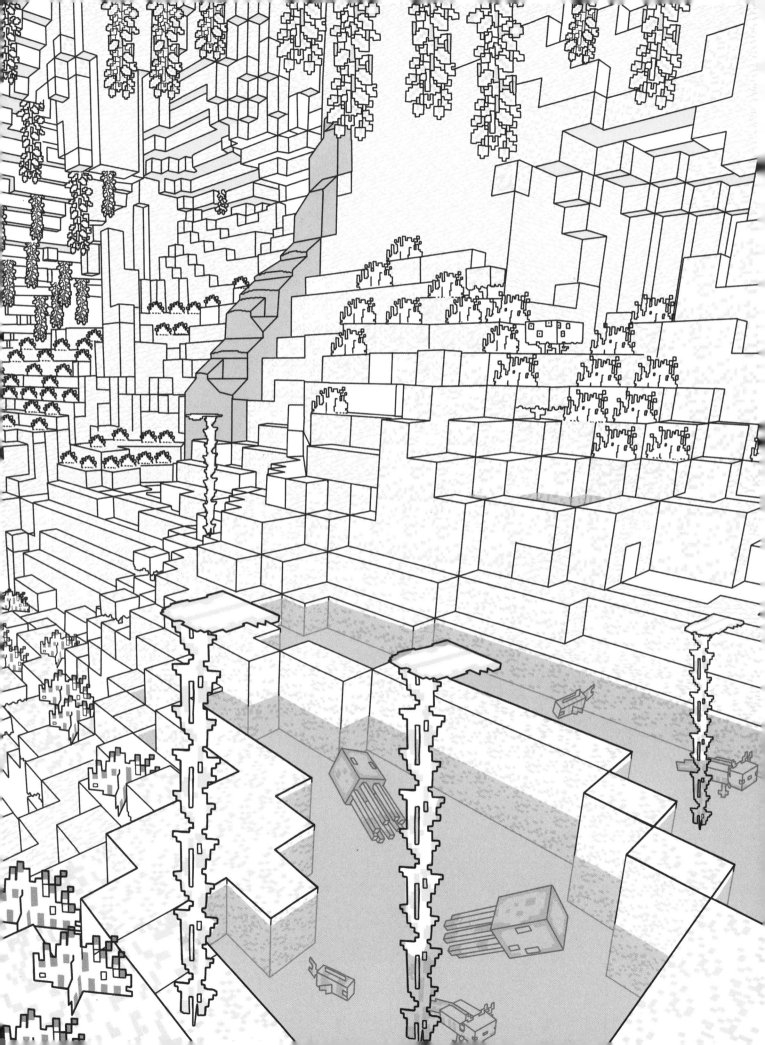

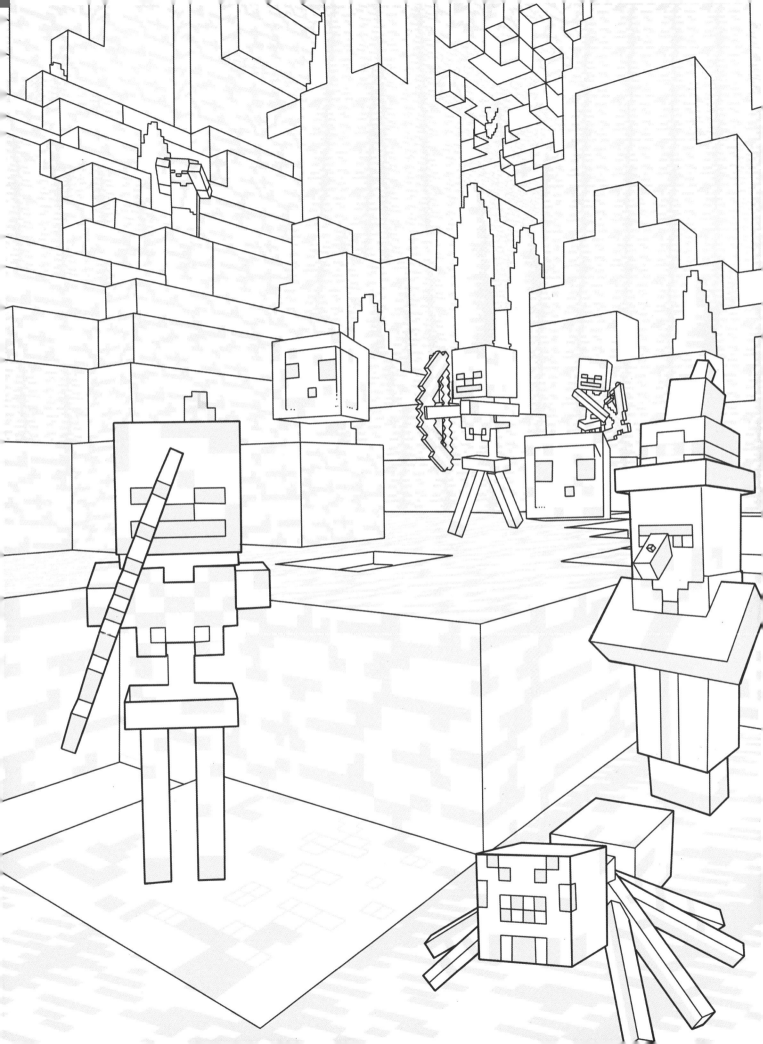

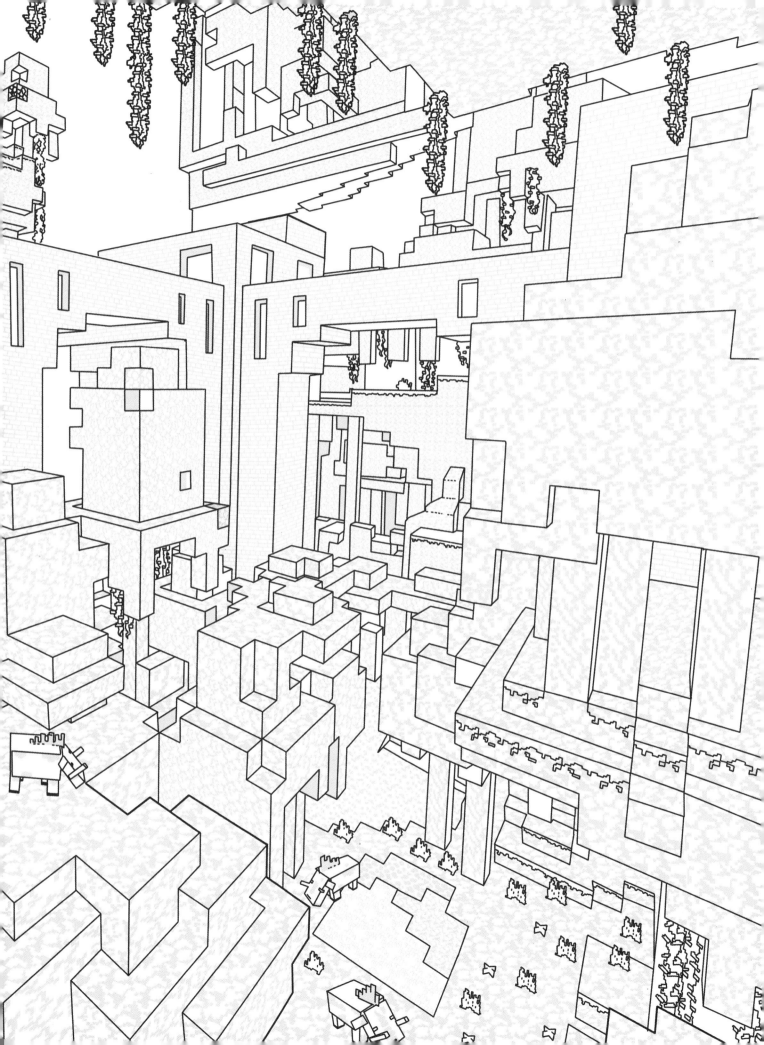

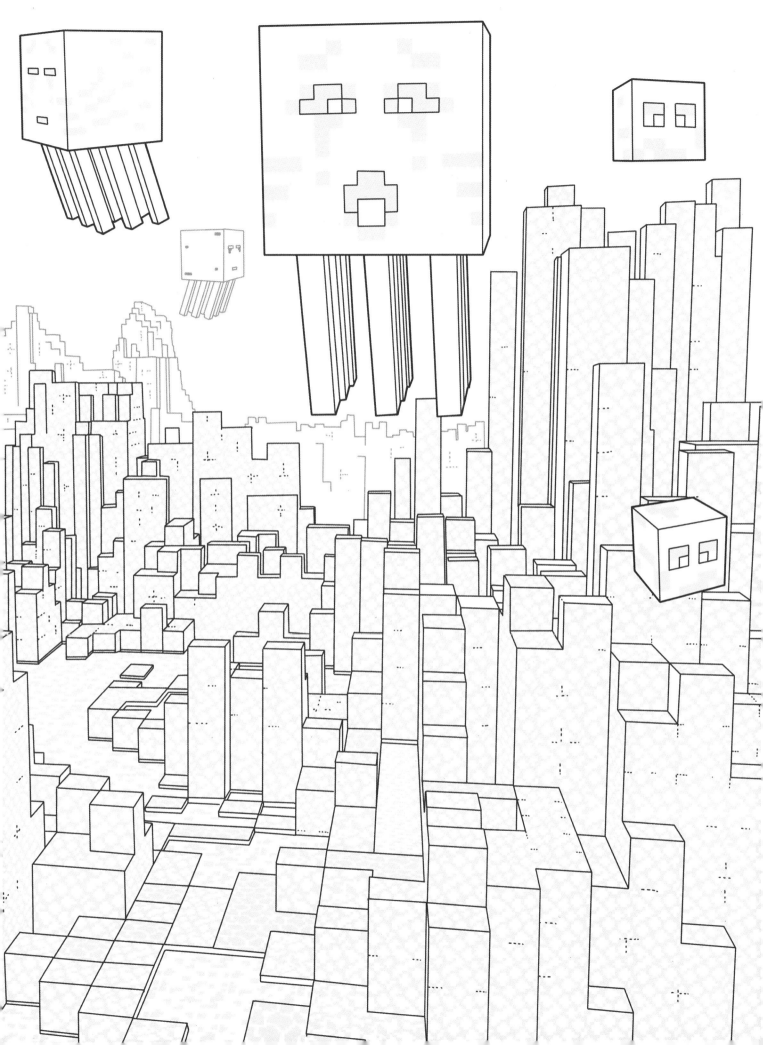

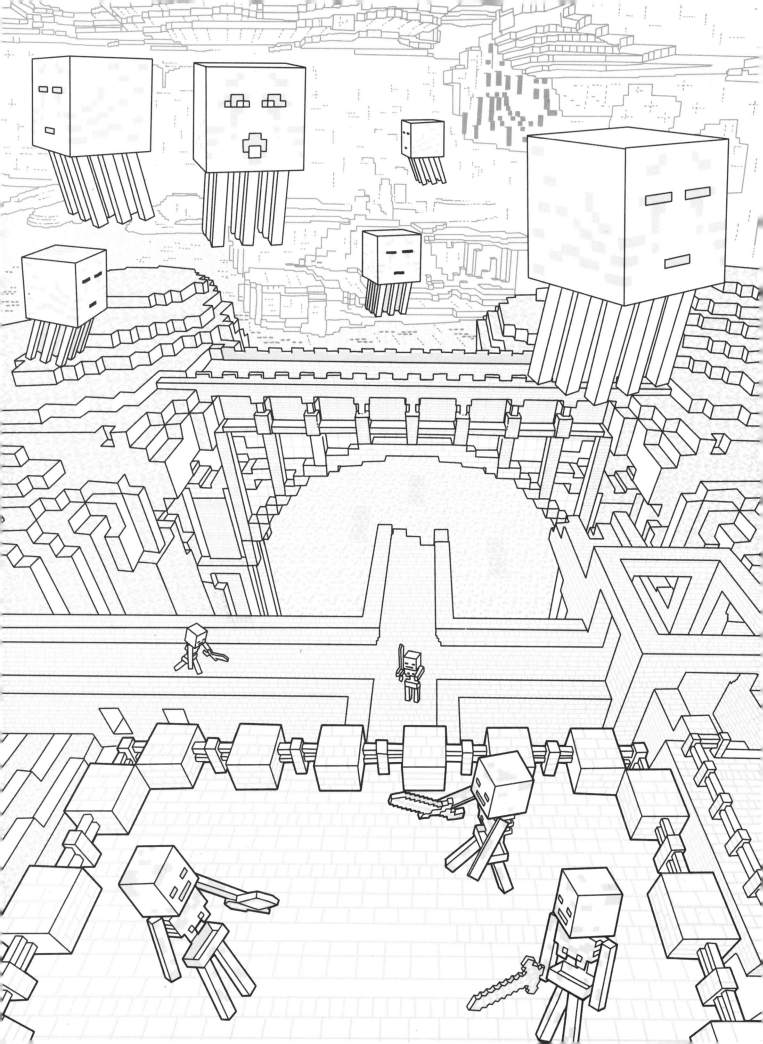

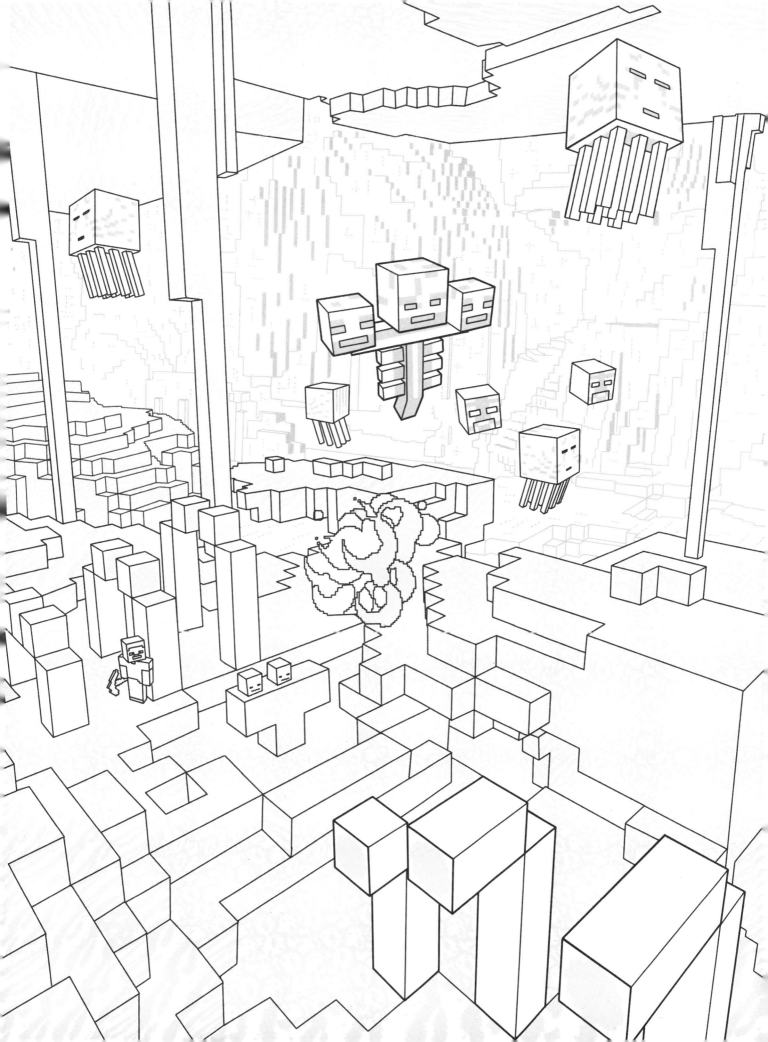

INSIGHT
EDITIONS

PO Box 3088
San Rafael, CA 94901
www.insighteditions.com

f Find us on Facebook: www.facebook.com/InsightEditions
⊙ Follow us on Instagram: @insighteditions

ISBN: 979-8-88663-695-6

Publisher: Raoul Goff
SVP, Group Publisher: Vanessa Lopez
VP, Creative: Chrissy Kwasnik
VP, Manufacturing: Alix Nicholaeff
Publishing Director: Mike Degler
Art Director: Catherine San Juan
Executive Editor: Jennifer Sims
Editorial Assistant: Jeff Chiarelli
Senior Production Editor: Nora Milman
Production Associate: Tiffani Patterson
Senior Production Manager, Subsidiary Rights: Lina s Palma-Temena

Illustrated by: Valentin Ramon
Minecraft Master Builder: Christian Glücklich

Special THANK YOU to Sherin Kwan, Alex Wiltshire, Audrey Searcy, and the Mojang Team

Hey Minecraft Community!
Look for
MINECRAFT: THE OFFICIAL POP-UP
available in stores and online.

ROOTS of PEACE 🌳 REPLANTED PAPER

Insight Editions, in association with Roots of Peace, will plant two trees for each tree used in the manufacturing of this book. Roots of Peace is an internationally renowned humanitarian organization dedicated to eradicating land mines worldwide and converting war-torn lands into productive farms and wildlife habitats. Roots of Peace will plant two million fruit and nut trees in Afghanistan and provide farmers there with the skills and support necessary for sustainable land use.

Manufactured in the USA by Insight Editions

10 9 8 7 6 5 4 3 2